Daily Warm-Ups
ART HISTORY

Meredith Ose

SGS-SFI/COC-US09/5501

1 2 3 4 5 6 7 8 9 10
ISBN 978-0-8251-6589-4
Copyright © 2010
J. Weston Walch, Publisher
40 Walch Drive • Portland, ME 04103
www.walch.com
Printed in the United States of America

Table of Contents

Table of Contents

Introduction

The *Daily Warm-Ups* series is a wonderful way to turn extra classroom minutes into valuable learning time. The 180 quick activities—one for each day of the school year—cover all aspects of a basic art history curriculum. They may be used at the beginning of class to get students focused, near the end of class to make good use of transitional time, in the middle of class to help students shift gears between lessons—or whenever you have minutes that now go unused. In addition to helping students gear up and focus, the warm-ups are a natural lead-in to more in-depth activities.

Daily Warm-Ups are easy to use. Simply photocopy the day's activity and distribute it. Or make a transparency of the activity and project it on the board. You may want to use the activities for extra credit points or as a check on your students' critical-thinking skills as they are acquired and built over time.

However you choose to use them, *Daily Warm-Ups* are a convenient and useful supplement to your regular class lessons. Make every minute of your class time count!

Note: Art history simply cannot be taught without showing examples of art. To support your instruction, works of art are named for each warm-up. You can find each work of art on one of the Web sites provided in the Appendix.

List of Works of Art

List of Works of Art

Greek

Etruscan

Daily Warm-Ups: Art History

List of Works of Art

Roman

- Roman architecture: arch, barrel vault, groin vault, p. 38
- Pont du Gard Aqueduct at Nimes, p. 39
- The Colosseum, Rome, pp. 40–41
- The Pantheon, Rome, pp. 42–43
- *Triumph of Titus*, relief sculpture, Arch of Titus, Rome, pp. 44–45
- *Equestrian Statue of Marcus Aurelius*, bronze sculpture, Piazza del Campidoglio, Rome, p. 46

Christian/Byzantine

- *Jacob Wrestling the Angel*, page from the *Vienna Genesis*, pp. 47–50
- *Empress Theodora and Her Attendants*, mosaic, San Vitale Church, Ravenna, pp. 51–53
- *Virgin and Child Enthroned Between Saints and Angels*, painting, Monastery of St. Catherine, Sinai, pp. 54–57

List of Works of Art

List of Works of Art

Italian Renaissance

- Fra Angelico, *The Deposition*, painting, pp. 79–80
- Pietro Perugino, *The Delivery of the Keys*, painting, pp. 81–83
- Leonardo da Vinci, *Mona Lisa*, painting, pp. 84–86
- Michelangelo, *Pietà*, marble sculpture, pp. 87–89
- Raphael, *The School of Athens*, painting, pp. 90–92
- El Greco, *The Burial of Count Orgaz*, painting, pp. 93–94
- Martin Schongauer, *The Temptation of St. Anthony*, engraving, p. 95
- Albrecht Dürer, *The Four Horsemen* from *The Apocalypse*, woodcut print, p. 96
- Jan Vermeer, *The Love Letter*, painting, pp. 97–100

Baroque/Rococo

- Palace of Versailles, France, p. 101
- Louis-François Roubiliac, marble sculpture of George Frideric Handel, pp. 102–103

Daily Warm-Ups: Art History

List of Works of Art

Daily Warm-Ups: Art History

List of Works of Art

List of Works of Art

List of Works of Art

Contemporary

Cave paintings at Lascaux, France

Prehistoric cave paintings were created in deep, dark, dank caves. Images were painted by hand. Imagine painting in these conditions. Imagine how the artist kept track of the sequence of events. Try drawing some of these prehistoric animals with charcoal or pencil on paper with your eyes closed.

1

Prehistoric

Cave paintings at Lascaux, France

Animals are the most commonly depicted subject of the prehistoric cave paintings. Why were animals so important in prehistoric society?

2

Cave paintings at Lascaux, France

Study the animal depictions in prehistoric art and find five other works of art from different time periods and cultures that depict animals. Sketch the animals.

3

Cave paintings at Lascaux, France

Describe the use of color in the cave paintings. Why did the people use these colors? Where did they get the colors from?

4

Cave paintings at Lascaux, France

Some scientists and art historians believe these paintings were part of a spiritual ritual. In your opinion, what was the importance of the cave paintings? What purpose might they have served?

5

Venus of Willendorf, stone statuette

Prehistoric people often created small hand-sized stone carvings of animals and human figures. Looking at the *Venus of Willendorf*, describe the characteristics of the carving using the elements of art.

6

Venus of Willendorf, stone statuette

What purpose do you think these small carvings served, and why?

7

Egyptian

Portrait Panel of Hesy-ra, Saqqara, wood relief carving

Looking at the carved figure in the work, describe the Egyptian style of representing the human figure. What does this panel seem to portray?

8

Great Pyramids, Giza

What purpose did the pyramids serve in ancient Egyptian society? Draw a diagram or an architectural plan of your own interior pyramid design.

9

Egyptian Hieroglyphics

Study the Egyptian hieroglyphic system of writing. Make a list of the top ten items you need to live in modern times and create an image or a symbol that represents each item. Share these with a friend and compare symbols. Are any of your symbols similar to the Egyptian hieroglyphs?

Egyptian Hieroglyphics

Compare and contrast the English alphabet with the Egyptian hieroglyphs.

11

Egyptian Hieroglyphics

What symbols do we have and use in modern times? Draw them.

12

Egyptian Hieroglyphics

Think of five other works of art throughout different time periods that use symbols and describe these symbols. Find examples if time permits. Do the symbols have anything in common?

13

Ashurnasirpal II Killing Lions, Palace of Ashurnasirpal II, Nimrud, Iraq, stone panel

Looking at the stone carving, what does this image convey about ancient Assyrian culture?

14

Assyrian

Ashurnasirpal II Killing Lions, Palace of Ashurnasirpal II, Nimrud, Iraq, stone panel

Compare and contrast the relief of *Ashurnasirpal II Killing Lions* with ancient Egyptian reliefs. Make a sketch of each side by side. Which style has more detail?

15

Audience Hall of Darius and Xeres, Persepolis, Iran

Looking at the Audience Hall of Darius and Xeres, how did Egyptian architecture influence the design at Persepolis?

16

Audience Hall of Darius and Xeres, Persepolis, Iran

Describe and draw the element of pattern that was used in the carving on the exterior of the Audience Hall of Darius and Xeres at Persepolis.

Audience Hall of Darius and Xeres, Persepolis, Iran

Describe the shape of and draw the different kinds of images you see throughout ancient patterns.

18

Carved Marble Figure from Amorgos, Cyclades

Compare and contrast the Aegean carved figure with the *Venus of Willendorf* from the prehistoric period.

Carved Marble Figure from Amorgos, Cyclades

The carved Cycladic figures were often buried with the dead. How does this compare with the burial rituals of the ancient Egyptians? What are some funerary rituals that are common today?

Octopus Vase, Palaikastro, Crete

Analyze and describe the *Octopus Vase*. What do you think this vase was used to carry?

21

Octopus Vase, Palaikastro, Crete

In your opinion, why do you think artists began to decorate utilitarian objects? What does the design of the *Octopus Vase* tell you about Aegean culture?

22

Greek

Psiax, *Herakles Strangling the Nemean Lion,* Attic black-figured amphora, Italy

Using the art elements, discuss and describe the Greek amphora (vase). What does the image portray?

23

Vases

Compare and contrast the Greek amphora with the Aegean *Octopus Vase*.

24

Vases

Looking at all the Greek vase styles, choose your favorite and sketch a scene in that style from your daily life.

Female Figure, limestone sculpture (kore), Archaic style

Describe the geometric forms that are descriptive of Archaic Greek style. Where do you notice the geometric shapes creating patterns? Sketch out the figure sculpture using only geometric forms.

26

Greek Orders of Architecture

Name and draw the three classical architecture orders in Greek architecture. Which one do you like the best and why?

The Parthenon, Athens

Analyze and describe the Parthenon. Which order has been used? Draw the order.

28

The Parthenon, Athens

Compare and contrast the Parthenon with the Great Pyramids in Giza.

29

Greek Theater, Epidaurus

The ancient Greeks invented the theater. Study the theater at Epidaurus and describe why it was designed in levels. Name all the theaters you have been to, inside and outside, that have the same design as the ancient Greek theater. What makes this a good design?

30

Greek

Discobolus, *Discus Thrower*, bronze sculpture, Classical style

Describe the *Discus Thrower*. What mood or feeling does this sculpture convey? What does this sculpture tell you about ancient Greek culture?

31

Three Goddesses, sculpture, Parthenon, Athens

How has the Classical style of sculpture developed since the Archaic style? Is the Classical style organic or geometric? Describe it.

32

Daily Warm-Ups: Art History

Nike of Samothrace, marble sculpture, Hellenistic style

Compare and contrast the Archaic style with the later Hellenistic style of sculpture. Which style portrays a greater sense of emotion?

33

Alexander the Great with Amun Horns, silver coin

Why has Alexander been identified with the horns of the ram-headed Egyptian god Amun? What does his expression convey?

34

Alexander the Great with Amun Horns, silver coin

Using the Alexander the Great coin as a reference, create your own coin. Who would you commemorate on your coin? How much would the coin be worth? What would the coin be made out of—metal, wood, plastic, or something else? Design both the front and the back of the coin.

She-Wolf, bronze sculpture

The *She-Wolf* sculpture is a symbol of ancient Rome that represents the mythological story of Romulus and Remus. The wolf and the two babies were created at two different time periods. Describe the two different styles you see.

36

She-Wolf, bronze sculpture

What does this sculpture seem to portray about the Etruscan people, and why?

37

Roman Architecture: Arch, Barrel Vault, Groin Vault

Romans were master architects and used old techniques in innovative ways. Use the arch, barrel vault, and groin vault together to create a drawing of a structure.

38

Pont du Gard Aqueduct at Nîmes

The Romans use the arch in bridges, sewers, and aqueducts more for efficiency than beauty. Describe how the Pont du Gard is visually beautiful as well as efficient.

39

The Colosseum, Rome

The Colosseum was a massive structure used for gladiator games. How does this form of entertainment compare to the large arena events we have today?

The Colosseum, Rome

Describe the design and use of the arch in the Colosseum. How did the Romans use pattern in their architectural designs? Sketch out a detail from the Colosseum to show the use of pattern.

41

The Pantheon, Rome

How does the Roman Pantheon temple compare and contrast with the Greek Parthenon?

42

The Pantheon, Rome

How is the Pantheon different from all other architecture of the time? How has the Pantheon inspired contemporary architecture?

43

Triumph of Titus, relief sculpture, Arch of Titus, Rome

How have the ancient Egyptian and Assyrian cultures inspired the relief work of the Arch of Titus?

Triumph of Titus, relief sculpture, Arch of Titus, Rome

Describe the composition and mood of the *Triumph of Titus* panel. How does Roman relief sculpture show depth?

45

Equestrian Statue of Marcus Aurelius, bronze sculpture, Piazza del Campidoglio, Rome

What does this statue reveal about the Roman culture? What did the Romans value, and how did they remember people?

46

Jacob Wrestling the Angel, page from the *Vienna Genesis*

How has ancient Egyptian art influenced the design of the *Vienna Genesis*, the oldest illustrated Bible manuscript?

47

Jacob Wrestling the Angel, page from the *Vienna Genesis*

Compare and contrast the *Vienna Genesis* with a Bible you would see today. How does the text become part of the composition?

48

Jacob Wrestling the Angel, page from the *Vienna Genesis*

Describe the style of the text in the *Vienna Genesis Bible* page. Write your name in a similar style and add an illustration depicting a sequence of events about yourself.

49

Jacob Wrestling the Angel, page from the *Vienna Genesis*

Illustrated Bibles were created to reach which classes, or types of people, and why? How did the illustrated Bibles help spread Christianity?

50

Empress Theodora and Her Attendants, mosaic, San Vitale Church, Ravenna

Describe the style of the figures in the mosaic from San Vitale Church.

51

Empress Theodora and Her Attendants, mosaic, San Vitale Church, Ravenna

What feeling or mood do you sense from this depiction? Why?

52

Empress Theodora and Her Attendants, mosaic, San Vitale Church, Ravenna

Describe the influence of Greek and Roman art styles in this mosaic.

53

Virgin and Child Enthroned Between Saints and Angels, painting, Monastery of St. Catherine, Sinai

Describe the style and composition of the figures in this Byzantine painting.

54

Virgin and Child Enthroned Between Saints and Angels, painting, Monastery of St. Catherine, Sinai

What is the feeling or mood conveyed in this Virgin and Child painting? Describe.

Virgin and Child Enthroned Between Saints and Angels, painting, Monastery of St. Catherine, Sinai

How does the use of color help to emphasize the main subject? Compare and contrast the use of color in the foreground and the background.

56

Virgin and Child Enthroned Between Saints and Angels, painting, Monastery of St. Catherine, Sinai

Describe and draw the geometrical composition that each figure is creating. Notice the use of geometric pattern on the clothing.

57

Animal Head from the Oseberg ship, carved wood, Norway

Describe how pattern and design played an important role in the Celtic style of medieval times.

Animal Head from the Oseberg ship, carved wood, Norway

Describe and draw the different types of patterns and shapes found in the Oseberg animal head carving.

59

Animal Head from the Oseberg ship, carved wood, Norway

Describe the importance of animals in medieval times. Choose an animal and draw it in a medieval pattern style like the carving from the Oseberg ship.

Animal Head from the Oseberg ship, carved wood, Norway

Compare and contrast these carvings with early Christian/Gothic carvings and sculptures.

61

Chi-Rho page from the *Book of Kells*

Describe the use of organic and geometric influences in the design of the Chi-Rho page.

62

Chi-Rho page from the *Book of Kells*

Looking at pages in the *Book of Kells* and other illuminated manuscripts, choose a name or symbol to illuminate and draw. What colors would you use? Describe your image.

Medieval Animal Art Style

Looking at medieval animal art style, choose an animal or create an animal composite. Use the animal in an interlocking design using geometric and organic patterns. Describe your choices.

64

Jamb Statues of Chartres Cathedral, France

How are these jamb statues different from any other wall/architectural carving? What mood best describes the figures outside the cathedral?

65

Jamb Statues of Chartres Cathedral, France

Describe the forms, patterns, and composition on the exterior of the Chartres Cathedral.

66

Jamb Statues of Chartres Cathedral, France

What geometric shapes are used to help create the human figures on the Chartres Cathedral? How has medieval art influenced the Gothic style?

67

Lorenzo Ghiberti, *Sacrifice of Isaac*, bronze door, Florence

Describe the use of geometric and organic design in Ghiberti's door.

68

Lorenzo Ghiberti, *Sacrifice of Isaac*, bronze door, Florence

Draw the geometric combination Ghiberti used to encase the scene of Isaac, and create your own image or scene inside.

Notre Dame de la Belle Verriere, stained-glass window, Chartres Cathedral

Describe the composition of the Notre Dame stained-glass window, and sketch it out on paper.

70

Notre Dame de la Belle Verriere, stained-glass window, Chartres Cathedral

Looking at the Notre Dame stained-glass window, describe the use of color and the effect of stained glass in the interior of Chartres Cathedral.

71

Gothic

Notre Dame de la Belle Verriere, stained-glass window, Chartres Cathedral

Using the Notre Dame stained-glass window as a reference, design your own window using patterns, shapes, figures, and colors. Describe your design.

72

Arena Chapel, interior view, Padua, Italy

Describe the use of frescoes inside the Arena Chapel. How is color used in this space?

Giotto, *The Lamentation*, painting

How is gold paint/pigment used in Gothic style? What does this color convey in Giotto's *The Lamentation*?

74

Jean Pucelle, *The Betrayal of Christ* and *The Annunciation,* pages from *The Hours of Jeanne d'Evreux*

Compare and contrast these illuminated pages with the pages from the *Book of Kells*.

75

The Limbourg Brothers, October Calendar from *Les Très Riches Heures du Duc de Berry*

How does this illuminated calendar emphasize rituals of the month and changing aspects of nature? How is color used to create emphasis and balance?

76

The Limbourg Brothers, October Calendar from *Les Très Riches Heures du Duc de Berry*

Looking at the Limbourg brothers' calendar pages, choose a time of year or month and create an interesting composition. Describe why you chose the particular time of year.

The Limbourg Brothers, October Calendar from *Les Très Riches Heures du Duc de Berry*

Compare and contrast the Limbourg brothers' illuminated calendar pages with those of the *Book of Kells* and/or Jean Pucelle's *The Hours of Jeanne d'Evreux*.

78

Fra Angelico, *The Deposition*, painting

Describe the use of color, value, and texture in Fra Angelico's *The Deposition*. What mood do you get from the painting?

79

Fra Angelico, *The Deposition*, painting

Looking at Fra Angelico's *The Deposition*, describe and draw the scenes in the foreground, midground, and background.

80

Pietro Perugino, *The Delivery of the Keys,* painting

Look at *The Delivery of the Keys.* How has Roman architecture influenced this Renaissance painting?

81

Pietro Perugino, *The Delivery of the Keys,* painting

Describe the use of one-point perspective. Draw out the basic perspective composition using the horizon line, the vanishing point, and converging planes.

82

Pietro Perugino, *The Delivery of the Keys,* painting

Describe the use of symmetry in Pietro Perugino's painting *The Delivery of the Keys.* How does symmetry help emphasize the subject? Create a symmetrical scene and an asymmetrical scene to compare.

83

Leonardo da Vinci, *Mona Lisa,* painting

What makes the *Mona Lisa* one of the most discussed paintings of all time? What makes this portrait unique, in your opinion?

84

Leonardo da Vinci, *Mona Lisa*, painting

Describe the use of light and shadow in the *Mona Lisa*. Try to create this effect using a soft pencil or stick of charcoal.

Leonardo da Vinci, *Mona Lisa*, painting

Compare and contrast the *Mona Lisa* with da Vinci's sketchbook drawings.

86

Michelangelo, *Pietà*, marble sculpture

Describe Michelangelo's use of marble and the composition of the *Pietà*.

Michelangelo, *Pietà*, marble sculpture

Compare and contrast Michelangelo's realistic sculpture style with the ancient Greek Archaic style.

88

Michelangelo

Michelangelo was a skilled painter, sculptor, and architect. How does this relate to the idea of the Renaissance or the "Renaissance man"? Who would represent this ideal of the Renaissance man or woman in modern society? Explain why.

89

Raphael, *The School of Athens*, painting

Describe the balance of figures and architecture in Raphael's painting *The School of Athens*.

90

Raphael, *The School of Athens*, painting

Describe and sketch *The School of Athens* in terms of proportion and perspective.

91

Raphael, *The School of Athens,* painting

Looking at *The School of Athens,* describe how Raphael uses color and value to emphasize space. Create a sketch using one-point perspective and use value to emphasize space.

92

El Greco, *The Burial of Count Orgaz,* painting

Compare and contrast El Greco's use of color with other Renaissance-style paintings. How does El Greco use primary colors in this painting?

93

El Greco, *The Burial of Count Orgaz*, painting

Describe the composition of *The Burial of Count Orgaz*. How does El Greco depict two worlds?

94

Martin Schongauer, *The Temptation of St. Anthony,* engraving

Looking at Martin Schongauer's *The Temptation of St. Anthony,* describe the use of fantasy as an element.

95

Albrecht Dürer, *The Four Horsemen*, from *The Apocalypse*, woodcut print

Albrecht Dürer was the premier woodblock printmaker. Looking closely at the print of *The Four Horsemen*, describe his use of line and shadow. Create a drawing in the style of Dürer's prints.

96

Jan Vermeer, *The Love Letter*, painting

Study Vermeer's painting *The Love Letter*, and sketch out the composition that is framing the subject of the two people. How does this composition draw you in and emphasize the scene?

97

Jan Vermeer, *The Love Letter*, painting

Where are you, the viewer, in relationship to the two women in *The Love Letter*? What mood does the framing of the main subject help convey?

98

Jan Vermeer, *The Love Letter,* painting

How does Vermeer's use of light add drama to his paintings?

Jan Vermeer, *The Love Letter*, painting

Looking at Vermeer's painting *The Love Letter*, create a dialogue between the two women. What are they talking about? What does the letter say? What is the woman's facial expression telling you about the situation?

100

Palace of Versailles, France

What does the Versailles Palace convey about the time period? What mood does the elaborate palace express?

101

Louis-François Roubiliac, marble sculpture of George Frideric Handel

How does this sculpture of George Frideric Handel, a famous composer at the time, reflect the mood and attitude of the time period?

102

Louis-François Roubiliac, marble sculpture of George Frideric Handel

Compare and contrast this sculpture with the sculptures of the Renaissance.

John Singleton Copley, *Watson and the Shark*, painting

How is the dramatic scene exaggerated in *Watson and the Shark*?

104

Honoré Daumier, *The Third-Class Carriage*, painting

What is Daumier saying about society in his painting *The Third-Class Carriage?*

Honoré Daumier, *The Third-Class Carriage*, painting

Describe the scene of people in the painting *The Third-Class Carriage*. Does this remind you of any experience you have ever had traveling?

106

Honoré Daumier, *The Third-Class Carriage,* painting

Compare and contrast Daumier's painting *The Third-Class Carriage* with Jacob Lawrence's painting series *The Great Migration.*

107

Honoré Daumier, *The Third-Class Carriage*, painting

How does Daumier use light in his paintings? Create an image, and use a strong light source as Daumier does.

108

Frédéric-Auguste Bartholdi, *Statue of Liberty*, copper sculpture, New York City

How does public art, like the *Statue of Liberty*, help lift the mood of society? Sketch a modern depiction of the *Statue of Liberty* using different clothing or objects to convey a new meaning for her symbolic structure.

109

Frédéric-Auguste Bartholdi, *Statue of Liberty*, copper sculpture, New York City

Compare and contrast the *Statue of Liberty* with the public work of Maya Lin's *Vietnam Veterans Memorial* in Washington, D.C.

110

Mary Cassatt, *The Child's Bath*, painting

Describe the use of pattern in *The Child's Bath*.

111

Mary Cassatt, *The Child's Bath*, painting

What feeling or mood is being portrayed in *The Child's Bath*, and why?

112

Henry O. Tanner, *The Banjo Lesson*, painting

Describe the use of texture and light in *The Banjo Lesson*.

113

Henry O. Tanner, *The Banjo Lesson,* painting

Why was Henry O. Tanner such an important and influential painter of the nineteenth century?

114

Henry O. Tanner, *The Banjo Lesson,* painting

What feeling is expressed in *The Banjo Lesson?*

Henry O. Tanner, *The Banjo Lesson*, painting

Compare and contrast Mary Cassatt's *The Child's Bath* with Henry O. Tanner's *The Banjo Lesson*.

116

Claude Monet, *Water Lilies*, paintings

Describe the use of color in Monet's *Water Lilies* series and how this defines the Impressionistic style. What materials are best for creating an Impressionistic style of work, and why?

117

Claude Monet, *Water Lilies*, paintings

Create your own flower scene in an Impressionistic style.

118

Auguste Rodin, *The Thinker*, bronze sculpture

Describe and draw the gesture of *The Thinker*.

119

Auguste Rodin, *The Thinker*, bronze sculpture

Rodin's *The Thinker* has become a popular symbol in modern-day society. What does the symbol represent to you?

120

Auguste Rodin, *The Thinker*, bronze sculpture

After looking at Rodin's sculpture *The Thinker*, create five figure drawings, with each figure in a different pose or making a different gesture. What does each gesture or pose symbolize?

Edgar Degas, *Little Dancer of Fourteen Years*, sculpture, mixed media

How does this Degas sculpture differ from any other sculpture up to this time period of the 1800s?

122

Paul Cézanne, landscape paintings

Look at several of the landscapes painted by Cézanne. Describe the use of color in his paintings. Using only complementary colors, choose any complementary color pair and create a landscape scene.

Georges Seurat, *A Sunday on La Grande Jatte—1884*, painting

Describe the painting style that is unique to Seurat. Create an image using the pointillism technique.

124

Georges Seurat, *A Sunday on La Grande Jatte—1884*, painting

Describe the figures in Seurat's painting and how Seurat seems to build them with color. Try to "build" your own figures using color as Seurat does.

125

Henri de Toulouse-Lautrec, posters

Look at several of Lautrec's posters. How does the artist use text as part of his composition? Create an advertisement using images and text in an interesting composition.

126

Vincent Van Gogh, paintings

Look at Van Gogh's wheat field landscapes, sunflower series, and his self-portrait. Describe the use of texture in Van Gogh's works. How can texture convey feeling or emotion?

127

Vincent Van Gogh, paintings

Describe the use of color in Van Gogh's paintings. How can color convey feeling or emotion?

128

Katsushika Hokusai, *The Great Wave at Kanagawa*, color woodcut

Describe the scene in Hokusai's print *The Great Wave at Kanagawa*. How does Hokusai emphasize the strength of nature in relation to the wave and the three fishing boats?

129

Katsushika Hokusai, *The Great Wave at Kanagawa*, color woodcut

Compare and contrast Hokusai's *The Great Wave at Kanagawa* with John Singleton Copley's painting *Watson and the Shark*.

130

Katsushika Hokusai, prints

Compare and contrast Hokusai prints with Albrecht Dürer's prints. How has printmaking developed since the Renaissance?

131

Henri Matisse, *Red Studio*, painting

Describe the use of color in Matisse's *Red Studio*. What does the color red symbolize in your opinion, and why? Assign an emotion to each color of the color spectrum and explain your choices.

132

Henri Matisse, cutout series, collage

Look at Henri Matisse's *papiers coupes*, or paper cutouts. Compare and contrast Matisse's cutout works with Jacob Lawrence's paintings.

133

Marc Chagall, *I and the Village*, painting

Describe the dreamlike mood portrayed in Chagall's painting *I and the Village*. Illustrate a dream you had that you thought was strange and unusual, or peaceful and beautiful.

134

Pablo Picasso, *Guernica*, painting

Describe the scene in Picasso's painting *Guernica*. What mood does this painting convey?

135

Pablo Picasso, *Guernica*, painting

How does the black-and-white composition of Picasso's painting *Guernica* help emphasize the subject matter? Create a series of black-and-white compositions in a cubist style.

136

Piet Mondrian, *Composition with Yellow, Blue, and Red,* painting

Describe the use of primary colors and geometric shapes in the works of Mondrian. Create your own drawing using primary colors and geometric shapes.

137

Salvador Dalí, *The Persistence of Memory*, painting

Describe Dalí's painting *The Persistence of Memory*. What do you think Dalí is saying about time and memory?

138

Salvador Dalí, *The Persistence of Memory*, painting

In Dalí's painting *The Persistence of Memory*, what objects or symbols does he use and distort? Draw these items on your paper, then select an item of your choice and distort or change its appearance to create a new meaning. Describe your drawing and what it symbolizes.

139

Frida Kahlo, self-portrait series, paintings

Frida Kahlo painted several self-portraits. Compare and contrast Kahlo's self-portrait paintings with Leonardo da Vinci's *Mona Lisa*.

140

Frida Kahlo, self-portrait series, paintings

What items did Frida Kahlo use in her self-portrait paintings as personal symbols? Create a self-portrait and include items that represent you. Describe the meaning of the items you chose to represent yourself.

141

Joan Miró, paintings

Look at the body of Joan Miró's work. Describe the use of shape and color in Miró's paintings. How do the shapes in Miró's paintings appear to be floating in space?

142

Joan Miró, paintings

Look at the body of Joan Miró's work. What do Miró's paintings remind you of? Choose one Miró painting and write a short story that reflects the image.

143

Joan Miró, paintings

Look at the body of Joan Miró's work. Create your own organic composition like Miró's, using primary colors.

144

Joan Miró, paintings

Compare and contrast Miró's paintings with those of the cubist painters. Create a design that combines Miró's organic style and the geometric style of the cubists.

145

Georgia O'Keeffe, paintings

Look at Georgia O'Keeffe's paintings of flowers. Describe the use of space in these paintings. Create three thumbnail sketches of any object, then enlarge the object to touch all four edges of your drawing paper.

146

Georgia O'Keeffe, paintings

Look at Georgia O'Keeffe's paintings of various subjects. Describe the use of color and value in O'Keeffe's works. What mood or feeling is expressed throughout O'Keeffe's paintings?

147

Georgia O'Keeffe, paintings

How does the mood of O'Keeffe's paintings relate to her surroundings where she lived and worked in New Mexico? Research the southwestern landscape and create a southwestern-inspired landscape drawing with color.

148

Jacob Lawrence, *The Great Migration* series, paintings

Look at *The First Wave of the Great Migration*—part I, panel one of *The Great Migration* series. Make a list of all the things taking place in this painting. What are the people doing? What is Lawrence saying about modern-day life?

149

Jacob Lawrence, *The Great Migration* series, paintings

Describe the story Lawrence is telling in *The Great Migration* series.

150

Jacob Lawrence, *The Great Migration* series, paintings

Why does Jacob Lawrence paint pictures about slavery? Why is it important for him to convey stories from the past?

151

Jacob Lawrence, *The Great Migration* series, paintings

Jacob Lawrence's paintings depict a time and a place. What time period would you paint from and why? Draw an image depicting an event in the past. This could be an important time in history or a personal story of your past.

Romare Bearden, mixed media

How are Romare Bearden's works unique to the art world? Describe Bearden's style.

153

Faith Ringgold, story quilts, mixed media

Compare and contrast Ringgold's story quilts with Bearden's quilts.

Faith Ringgold, story quilts, mixed media

Create a story quilt design similar to Faith Ringgold's story quilts. Include a frame and text or complete story within the composition. Think about depicting a family gathering, a party, a trip to the beach or to the city, or a day spent in a garden or park.

155

Faith Ringgold, mixed media

Compare and contrast Faith Ringgold's paintings with Jacob Lawrence's paintings.

156

Andy Warhol, *Marilyn Diptych*, silkscreen painting

How was fame an important theme in Warhol's work?

157

Andy Warhol, *Marilyn Diptych*, silkscreen painting

Why do you think Andy Warhol chose movie actress Marilyn Monroe for some of his compositions?

158

Andy Warhol, paintings

Describe the use of color and composition in Andy Warhol's works.

159

Keith Haring, drawings/paintings

Look at a selection of Keith Haring's works. Describe the mood or feeling conveyed.

160

Keith Haring, drawings/paintings

Create a scene of people in the abstract style of Haring.

Keith Haring, drawings/paintings

How does Keith Haring express movement and sound in his works? Make three original thumbnail sketches using Haring's style of depicting movement and sound.

Keith Haring, drawings/paintings

Compare and contrast Keith Haring's works with those of prehistoric cave paintings found in Lascaux, France.

163

James Van Der Zee, photography

Describe some of the themes of Van Der Zee's photographs.

Alfred Stieglitz, *The Steerage*, photograph

Describe the event captured in Stieglitz's photograph. Draw the composition on paper and describe how you think the picture was taken.

165

Alfred Stieglitz, *The Steerage*, photograph

Compare and contrast Alfred Stieglitz's photograph *The Steerage* with Jacob Lawrence's *The Great Migration* series of paintings.

166

Robert Frank, photography

What are some themes in Robert Frank's photographs? Make a list of times and places where you typically take pictures. Compare and contrast your photos with Frank's works.

167

Dorothea Lange, *The Migrant Mother*, photograph

Why do you think Dorthea Lange's photograph *The Migrant Mother* touched so many people? How did it bring to light the conditions at the California camp?

168

Maya Lin, *Vietnam Veterans Memorial*, sculpture/monument

What would you create a memorial of? What materials would you use to convey your message, and why?

169

Maya Lin, *Vietnam Veterans Memorial*, sculpture/monument

Describe the composition of the *Vietnam Veterans Memorial* and sketch it on your paper. How does Lin use space and movement in her design?

170

Frank Gehry, architecture

Describe the use of geometric and organic forms in Gehry's designs. Create a three-dimensional drawing combining geometric and organic forms.

171

Frank Lloyd Wright, architecture

Compare and contrast the architectural styles of Frank Gehry and Frank Lloyd Wright. Which style do you prefer, and why?

172

Graffiti Art

Compare and contrast graffiti art with the prehistoric cave paintings.

Graffiti Art

What does graffiti convey about modern society? Where do you usually see large displays of graffiti art?

174

Graffiti Art

In your opinion, is graffiti a true art form? Explain. Where should graffiti be allowed, or should it all be illegal?

175

SunTek Chung, photography

Look at SunTek Chung's images, such as *Ninja Love* and *The South, The South*. How does the work of this artist juxtapose heritage and contemporary culture?

176

SunTek Chung, photography

How does SunTek Chung create his photographs? Compare and contrast Chung's photographs with Robert Frank's photographs.

Kehinde Wiley, portrait paintings

View the works of Kehinde Wiley at his Web site or at the National Portrait Gallery "Recognize!" exhibit. Describe how Wiley juxtaposes the past and the present in his paintings.

178

Kehinde Wiley, portrait paintings

Look at Kehinde Wiley's paintings. What mood does he convey through this process of juxtaposing time, people, and places?

179

Kehinde Wiley, *Ice T*, painting

What is Wiley trying to convey in the portrait of Ice-T? Choose a famous person you would paint a portrait of and then choose a different time period to place that person in. Describe your choices and how what you have selected conveys a new meaning.

180

Most answers will vary. Questions do not necessarily have one correct response but many possible responses. These prompts are used to engage students' ability to debate and support their opinions.

1. Drawings will vary. They should have a sense of movement, crowded space, and overlapping gestural images of animals. Drawings may be smeared or blurry if using charcoal.

2. The people depended upon animals for food and clothing, utilized bones and skins as tools and shelters, and, scientists speculate, had a spiritual connection with animals.

3. Sketches may vary drastically, as animals are depicted in almost every period and culture, including Egyptian, Assyrian, Greek, Roman, African, Aboriginal, modern, and contemporary.

4. Colors found in prehistoric art are earth tones—reds, browns, black, and yellows. The pigments were a reflection of what early people could make from natural resources such as plants, berries, blood, and burned wood.

5. Opinions will vary. Some believe the paintings were part of a one-man journey into adulthood. Other thoughts portray hunters going into the caves and painting pictures of their kill as an offering for taking and using the animals and for continued success in future hunts.

6. Shape—round. Form—full, dense. Color—neutral, natural. Space—compact, solid. Texture—rough. Value—light-colored stone, washed-out gray.

Daily Warm-Ups: Art History

7. Some think these statuettes served as fertility goddesses, fertility sculptures for individual families.

8. The figure is stiff, upright, seen from one side, geometric, with a smooth finish to the surface. The figure is a man. It shows items he used for work. He was likely a scribe.

9. They served as burial grounds for the pharaohs/kings and queens. Student diagrams will vary.

10. Examples: cell phone, computer, books, TV, pencils/pens, paintbrush, car, purse/backpack, house, school bus, food, keys, clothes, jewelry, money, family, pets, friends.

11. Compare: simple line drawing, each is symbolic of language, types of communication. Contrast: pictograph construction vs. singular sound/letter construction.

12. Examples: road signs, computer icons, restroom signs, electric symbols, product brand symbols/advertising.

13. Answers will vary. Two examples are the sun and eye. Sun symbols and eye symbols are seen in ancient Egypt and modern times but differ in meaning. The use of these common symbols over time suggests importance. The sun is important to all living forms. The eyes are known as "the windows to the soul" and are important in daily function.

Daily Warm-Ups: Art History

14. The mood is defensive, strong, protective, and fierce because of the posture of the lions and the use of the gated wall/fortress.

15. The Assyrian relief depicts more movement, whereas Egyptian reliefs depict figures that are still, stiff, rigid. Assyrian design has detail that is more realistic.

16. Relief sculptures are a dominant feature of architectural decoration and storytelling/preservation of culture.

17. Carvings show geometric, abstract forms of people and plants.

18. Images are geometric and organic representations of people, plants, animals, and so on.

19. Aegean sculpture has an extremely smooth texture, and the form is more geometric.

20. Egyptians also buried their dead with carved objects, such as scarabs (beetles), which were a symbol of the afterlife. Today, many people bury the dead in almost the same ways. Bodies are dressed in a nice outfit or favorite clothes. Personal objects are often placed in a casket. Some people choose to be cremated.

21. The vase is round, with reds and blacks (earth tones). It has an organic design of the octopus and a geometric design of the vase. The vase is utilitarian, maybe used to carry fresh-caught octopus, or water for cooking and drinking.

Daily Warm-Ups: Art History

22. The decoration of an object told a story, acted as a visual language and told you what the object was used for, and was also visually interesting when not in use. The vase can tell you that the Aegean people utilized and respected the ocean, were skilled craftspeople, and appreciated design.

23. It portrays fighting and power, with strong, bold, and simple use of color, while also preserving a story or mythology of the culture.

24. Compare: Same use of earth tones indicates that technology and trend have not changed. Contrast: soft vs. hard, organic vs. geometric.

25. Drawings will vary—for example, a scene of kids playing a game.

26. Archaic style: stiff figure, not realistic, more abstract, little emotion. Geometric shapes: concentric squares on the dress, square pattern in the hairstyle.

27. Doric—most simplistic, smooth or fluted column. Ionic—fluted with rolled tops/volute. Corinthian—most elaborate, flower/acanthus detail at the top of the column. Student opinions will vary.

28. Responses will vary. Made of marble, the structure has eight columns on each of the short sides and seventeen columns on the long sides. It is rectangular. The roofline is triangular. There are sculptural reliefs. Doric order has been used.

29. Both are geometric forms. One is an open structure; one is a closed form. One is on the surface; one extends underground.

30. The theater has a stacked design so the stage sound will travel up and everyone can view the stage. It also wraps around the stage, enabling more people to attend.

31. It represents an athlete. It conveys the sense that physical fitness is important. The mood expresses power, strength, and energy.

32. The Classical style is more of a fluid, organic design; the marble looks as if it is made out of fabric. Classical is more organic, free-form, and natural.

33. Hellenistic: exaggeratedly realistic, energetic, strong posture, emotionally charged. Archaic: geometric, rigid, more abstract.

34. The horns on Alexander are representative of power, strength, and leadership; they compare Alexander to the Egyptian god Amun. His expression conveys confidence, power, and leadership.

35. Coin designs will vary. Sample subjects: Martin Luther King, Jr., Hillary Rodham Clinton, Barack Obama, Mother Theresa.

36. Wolf: Archaic style, stiff, more abstract. Babies: added during the Renaissance period, realistic style.

37. The Etruscans have a strong mythological history; their art is used to celebrate their beliefs and preserve their history.

38. Drawings will vary.

39. It features geometric patterns, a variation of pattern by mixing small and large arches, and negative space. It frames the landscape instead of blocking it, while using less concrete.

40. They are very similar, except today the sporting events are usually team-oriented, and athletes are not killed. The design is very much the same, but materials such as steel and iron are used in our modern day. We also have open and enclosed arenas just like the Colosseum.

41. The arch is symmetrically stacked; the Colosseum has an open design constructed by the stacked arches.

42. Both structures have an opening. The Parthenon is rectangular; the Pantheon is circular. Both let in natural light and create a connection to nature.

43. The building has a circular opening called an oculus (similar to the word *ocular*, "having to do with eyes"), which lets in light like a modern-day skylight.

44. The relief design conveys a story of war. The figures are drawing our attention away, outward, toward an event taking place. The figures are carved in profile.

Daily Warm-Ups: Art History

45. The composition is crowded. The scene is exciting, defensive, and powerful with the influence of war or victory, because the chests of the horses and men are held high, which shows pride and power. The background is a very low relief carving while the foreground is in high relief, creating a sense of depth in the composition.

46. Roman culture was warlike. Romans valued protecting their beliefs and preserving their history. They were proud of and celebrated their dedicated contributing citizens. This statue celebrates a powerful, peace-loving, philosophic emperor as symbolized by the proud horse with one leg up.

47. Egyptian art influence is reflected by the use of storytelling through pictures of an important sequence of events.

48. There are typically no pictures in a modern Bible except for children's Bibles. The text and the imagery make this book accessible to both literate and illiterate people, thus reaching more people and spreading the message of the Bible. The text is very stylized and graphic, becoming part of the overall image on the page.

49. The text is a stylized font type, not like handwriting, but with more formal, bold lettering. Student illustrations will vary.

50. Illustrated Bibles were important works of art and faith. Because of the use of text and imagery, more people could learn about the Christian religion, and thus the lessons and stories could be related again and again, spreading religious belief.

51. The figures are stiff and stylized and have an archaic influence in their geometric form.

52. The figures convey a serious, quiet feeling.

53. The forms are geometric, stiff, and archaic. The mosaic has many architectural elements, such as the column pedestal, the fountain, the patterned design on the walls framing the scene, and the frieze-like depiction on Theodora's dress.

54. Style: stiff, stationary, archaic figures. Composition: geometric designs and symmetrical arrangement.

55. A serious mood is reflected in facial expressions, the arrangement of figures, clothing that appears to be ceremonial, and the suggestion of a religious event, as shown by the use of crosses and gold orbs behind figures.

56. The contrast of neutral colors throughout most of the painting with the bright, shiny gold orbs behind the four figures helps portray this image as an important religious story. The background has an even more washed-out use of neutral colors and appears to fall back, making the foreground more pronounced.

57. Figures show symmetrical composition and geometric patterns. Drawings should show this.

58. Celtic/medieval design has a bold, exaggerated use of pattern, usually filling the entire space of the composition. Pattern use is crowded—interlocking geometric and organic, bold, stylized design. Everyday objects are heavily decorated.

59. Figures show symmetrical composition and geometric patterns. Drawings should show this.

60. Animals played a daily role in medieval art, from herding to mythological creatures. Often birds and composite beasts were depicted.

61. Medieval carvings are more abstract and depict imaginary beasts, and are completely covered with interlocking patterns.

62. Within a geometric shape there are swirling organic patterns; within the organic swirling shape of the font are geometric, symmetrical patterns.

63. Drawings/descriptions will vary.

64. Drawings/descriptions will vary.

65. These are the most three-dimensional reliefs; they appear to be free-standing sculptures. The mood is serious, magical, meditative.

66. The exterior is covered with relief design, using figures and animals. The arch friezes have linear patterns of figures and decoration. The columns of the jamb statues feature alternating use of textured patterns.

67. Vertical rectangular forms create the figures. Like medieval design, geometric patterns continue to play an important role in Gothic design, but the patterns are spaced out more than in medieval design. Gothic design is more open and balanced, but still has very busy use of space.

68. Geometric framing: combination of four semicircles (or quatrefoil) and a central square. Organic: subject matter, bronze relief of Isaac, smooth texture, and realistic figures.

69. Drawings will vary.

70. The window is shaped like a narrow arch, with square spaces filling the interior.

71. The stained-glass windows were not meant to shed light on the interior with bright sunlight, but to transform natural light into a burst of color. This burst was known as *lux nova,* or new light. It was meant to represent God as the God of light.

72. Drawings/descriptions will vary.

73. Frescoes completely cover the interior of the chapel. The colors are bright blues, yellows, golds, and reds. Cool blue and green backgrounds contrast with the warm reds, yellows, and golds.

74. Gold is used symbolically to represent important religious people and their stories, also drawing attention to the subject of the story. Gold illuminates or celebrates Christianity.

This contrasts with the common people in the background without the gold orbs.

75. These pages depict realistic figures. The imagery is the dominant focal point rather than the text, which seems to be more of an accent to the page and the images.

76. The events depicted in the October calendar are scenes of harvest, the clothing is heavier on the people, and the horse has a blanket. The colors are mostly neutral, but the calendar and the two figures in the foreground are bright blue and red, drawing our attention to the subjects and emphasizing the seasonal events of October.

77. Drawings/descriptions will vary.

78. These calendar pages were not religious; they were intended for use by the king of France, not for masses of people nor for the Church. The colors are much brighter and saturated; the images portray daily seasonal events.

79. Color: bright and bold gold, reds, and blues. Value: dark and light creating depth/dimension. Texture: smooth, seamless. Mood: magical, dreamlike, sorrowful.

80. Foreground: figures on their knees and crowd surrounding Jesus. Midground: Jesus being taken off the cross, focal point, central. Background: landscape, angels hovering around the crowded scene.

81. The arches and domed building are elements of Roman architecture.

82. One-point perspective is used to create the illusion of depth. The converging lines of the plaza street pattern draw the eye up to the horizon line and into the church/structure. Drawings should show this.

83. This painting is primarily symmetrical with a few details scattered, such as the people in the background. Central is the symmetrical church, and the focal point is St. Peter receiving the keys from Christ. Equally on both sides are two arched structures and two groups of people looking on. Scenes should clearly be symmetrical and asymmetrical.

84. Mona Lisa's smile and the realistic appearance were extraordinary for the time. Student opinions will vary.

85. The use of light is very soft; a smooth blending of paint lets highlights and shadows run seamlessly into one another in a smooth gradation.

86. *Mona Lisa* was a finished oil painting; sketchbook drawings are pen-and-ink line gestural drawings or drafts for future paintings.

87. The marble appears to be as soft as skin, the texture is smooth and fluid, and the lines are organic and realistic. The composition is triangular.

88. Michelangelo's sculptures are dramatic and full of emotion, whereas Greek Archaic sculptures are almost void of emotion and are stoic, heavy structures.

89. The "Renaissance man" was the idea of a person being educated and skilled in many ways, with the ability to accomplish great things in life. Modern-day choices will vary.

90. Both figures and architecture are symmetrically balanced.

91. The painting uses one-point perspective and symmetrical balance; the horizon line cuts the composition into thirds, and arches are symmetrical and echoed, creating the illusion of depth.

92. Raphael uses bright, bold colors to draw your attention to the focal point, which is central. Bright color is also used to frame the composition. Raphael uses a wide range of values, giving the sense or illusion of depth.

93. El Greco's color is heavier, richer, bolder, and brighter. He uses primary colors to emphasize the subject and focal points of the painting.

94. The cloud-like drape of gray, white, and blue separates the composition into two sections— earthly and heavenly bodies. The winged figures and depiction of Christ at the center top are painted in a more fluid manner.

95. The composite fictitious animals create a fantasy world.

96. Dürer uses a series of bold black lines of the same weight/thickness. Lines closer together create a shadow effect; lines farther apart create a light area. Student drawings will vary.

Daily Warm-Ups: Art History

97. The framing of the doorway directs your attention to the subject immediately because of the strong use of light on the subject and the muted dark space of the framing doorway. Sketches should show this.

98. The viewer is in the hallway perhaps, looking onto a scene she or he is not a part of. The mood is secretive or suspenseful.

99. The limited use of light only on the subject creates a dramatic spotlight effect; everything else around fades away.

100. Answers will vary.

101. It conveys extreme opulence and excess of ornamentation. It expresses a dramatic, luxurious mood/feeling.

102. Music and art were in abundance and celebrated; this was a time of happiness.

103. This sculpture is happy and lighthearted compared with the serious religious Renaissance sculptures.

104. The position of the figures is extended. The figure of Watson in the ocean is naked and positioned in a dramatic pose, unrealistic but conveying a sense of emotion, urgency, and danger.

105. People are separated based on class status. The third-class people are tired, separated from the majority on the carriage, and seemingly dressed in a less fancy way than the passengers with hats and suits. Society is segregated and judgmental.

Daily Warm-Ups: Art History

106. Personal answers will vary. The scene is described on the previous page.

107. Both portray people traveling. Daumier's style is gestural but more realistic than Lawrence's abstract painting style.

108. The use of light is limited, highlighting important facial features among a mostly dark and dreary composition. Student images will vary.

109. Public art can symbolize a positive time or message and uplift people or remind them of their values in life. Student sketches will vary.

110. The *Statue of Liberty* has a positive symbolic meaning and represents national freedom, as well as the history of the American people and the waves of immigrants who helped build modern culture. It also stands as a symbol for the United States as a free country. The *Vietnam Veterans Memorial* serves as a different kind of reminder of our past, commemorating and honoring U.S. troops who fought in a controversial war and reminding us of how many died serving their country.

111. The pattern on the wallpaper is an organic design, the woman's dress is a geometric pattern, and the rug on the floor is also geometric.

112. The mood is maternal and comforting, conveying a universal message of intimate maternal love.

113. The short and layered brushstrokes create a rough texture. The use of soft colors creates a soft, warm glow washed over the whole painting. The intense glow from the right suggests a fireplace, also creating a warm mood.

114. Tanner was a minority painter, and the first important African-American painter of the time period.

115. The feeling is warm and caring because of the sense of the fireplace and the use of color and light filling the space around the older man and young boy as they sit close together.

116. Cassatt's use of color is brighter and bolder, and the surface is smooth. Tanner's scene is open, with softer colors and a choppy texture created by short brushstrokes and layers of paint. Both images are intimate moments shared between the young and old.

117. The colors are soft and muted, heavily blended, foggy, and with a creamy texture. Impressionists typically use the best quality oil paints. The materials provide the desired effect and offer purity and potency of color.

118. Drawings will vary.

119. The gesture is tight, compact, enclosed. Drawings should show this.

120. Answers will vary.

121. Drawings will vary.

122. The sculpture uses different types of media—materials combined to create a finished work.

123. Cézanne uses complementary colors—oranges and blues. Drawings should use complementary colors.

124. Seurat uses layered dots of color (pointillism). Images should do the same.

125. The figures are solid; they are full stylized figures, not realistic.

126. The text or advertisement is large and ties into the color scheme of the design; it is balanced, not overlapping, not taking away from the image. Student advertisements will vary.

127. Van Gogh expresses intensity and conveys an anxious feeling though the use of short lines; intense, pure colors; movement; and vibration.

128. Van Gogh uses bright, bold color. He stated that certain colors represented specific emotions. Bright colors can be happy or intensely anxious; dark colors can be calm or mysterious or sad.

129. The wave is huge in comparison with the fishing boats, representing that nature is larger and more powerful than the acts of human beings.

130. Copley's painting is more realistic. Hokusai's work is more stylized and abstract.

131. Printmaking has changed in the use of colors. Hokusai's prints have bright, bold, pure colors. Both artists have a strong use of line and simple use of shadow. Hokusai's images are flatter than Dürer's.

132. The painting is an explosion of the color red. Student opinions and color choices will vary.

133. Both have a similar sense of abstract design and bright use of solid colors. Other than the different use of materials, the works of the artists differ in theme.

134. The overlapping and floating appearance of images conveys the dreamlike mood. Student illustrations will vary.

135. The scene is black and white, creating a bold graphic scene of overlapping figures, objects, and animals. The mood is of chaos and war.

136. The black-and-white composition gives a bold, stark importance to the subject. The absence of color draws your attention to the scene and the emotional story being portrayed. Student compositions will vary.

137. Simplistic, minimal use of solid strips of primary colors creates a series of geometric shapes. Student drawings will vary.

138. The droopy, melting objects in a landscape setting are dreamlike, not real. Dalí suggests that time and memory are not real, or he is questioning reality.

139. Dalí distorts pocket watches. Student drawings will vary.

140. Both are mysterious in the facial expression; both are looking forward as in a traditional portrait painting. Kahlo uses brighter colors and appears to be telling a story with objects and other clues.

141. Flowers, body braces, big dresses, animals, changing hairstyles, handwriting. Self-portraits will vary.

142. Miró uses organic, biomorphic shapes and flat, bold colors. Use of free-form and imagery makes the works appear to swirl and float.

143. Answers will vary.

144. Drawings will vary.

145. Miró's paintings contain organic, free-floating shapes. Cubist paintings are geometric, sharp-edged, overlapping. Student designs will vary.

146. O'Keeffe uses the entire space of the composition. The flowers run off all the edges of the paintings. They are larger-than-life depictions of flowers. Student drawings will vary.

147. The colors and values are soft and have a gradual change in value, creating a dreamlike mood.

148. The colors she uses reflect the southwestern sky and light of the desert. Her paintings have a calm, dreamlike mood to them. Student drawings will vary.

149. People—men, women, and children—are crowding in lines to board buses or trains to Chicago, New York, and St. Louis. Lawrence uses bold, flat colors and pops of primary colors. The people have no specific identity other than African American. Everyone appears to be headed away; no one is going against the group of travelers. The artist is showing how hordes of people at the time were heading to the big cities for big opportunities.

150. This is a metaphor for African Americans migrating to the northern cities for better opportunities, equality, work, and education.

151. He is honoring his African-American heritage. It is important to Lawrence to be in touch with his cultural roots, to depict images that are both good and bad, and to show this to the modern world.

152. Drawings will vary.

153. Bearden creates collages and large quilts that are like paintings. He has a unique abstract style of patchwork quilting and collage.

154. Ringgold's story quilts often contain text or a complete story wrapping around like a frame, with the image quilted inside the frame. Bearden also creates quilts, but they are much more free-form in composition, far different from the traditional geometric patterned quilts of the nineteenth century.

155. Story quilt designs will vary.

156. Compare: The figures and shapes within the compositions are geometric and flat; works share the similar subject matter of African-American daily life in the city. Contrast: Lawrence paints and does not use text within the compositions.

157. Warhol chose images of current famous people such as actress Marilyn Monroe and famous objects/images such as the Campbell's tomato soup can to make social commentaries on pop culture.

Answer Key

158. Marilyn Monroe was extremely popular in the 1950s and early 1960s, and her sudden death at the age of 36 in 1962 caused a national media sensation. Warhol drew upon pop culture icons, thus making Monroe's image an easy target to turn into an object or a commercial use.

159. The colors are loud, vibrant, bright, and bold. Sometimes Warhol used neon as an accent and set images against a white or neutral background.

160. Energetic, free-spirited, fast, gestural, childlike, creative, fun.

161. Drawings will vary.

162. Haring draws short lines that wrap around the object so that the object appears to be active, alive, or loud. One example is how a lightbulb has six little lines dashed around the top of the bulb to represent light or electricity. Student sketches will vary.

163. Compare: very similar; fast line drawings that show a sequence of moving subjects. Contrast: different in materials and colors. Haring uses bright colors that prehistoric people did not have.

164. Famous people from the Harlem Renaissance, families, portrait sittings, public events.

165. The image of many people crowded on a boat on a trip to Europe shows two different levels of passengers, both physically and socially. Student drawings and descriptions will vary.

166. Compare: Both depict images of people awaiting a voyage; diagonal lines help break up the composition into sections. Contrast: color painting vs. black-and-white photograph.

167. Themes: everyday events of people living in the city, buses, cars, people working, people waiting—mostly candid shots. Student lists and comparisons will vary.

168. The image was so emotional and realistic that it brought attention to the story behind it.

169. Answers will vary.

170. The memorial is set up as two ramps converged in a V shape built into the flat ground. When you walk into the memorial to read the names engraved upon the entire surface, as the path continues, you gradually walk deeper into the ground and then walk up and out along the other side. It is a symmetrical design; the center is the deepest level of the structure.

171. Gehry combines traditional geometric forms with organic curves and patterns to create his "deconstructed" structures. He is morphing the two forms together. Student drawings will vary.

172. Gehry's work often seems unfinished, abstract, and untraditional. Wright mostly uses traditional forms. Student opinions will vary.

173. Compare: public forms of art, nontraditional, not in galleries, express culture and lifestyle. Contrast: Colors are different; graffiti subjects usually include a form of text, such as a name.

Daily Warm-Ups: Art History

174. Graffiti can be a positive and legal display of public art that represents modern culture, usually connected to modern youth, or it can be vandalism. It is often seen on brick walls, in parks, on train cars, and in cities.

175. Answers will vary.

176. Chung combines images of Asian and American heritage and cultural stereotypes to create a sarcastic commentary on cultural clichés.

177. Chung stages fictitious scenes of juxtaposing objects and takes pictures of the scenes, capturing his view, telling his story, and conveying his message or unique viewpoint. Chung's photographs are staged scenes, while Frank's photographs are candid images of everyday real life.

178. Wiley uses traditional elements of Renaissance portrait painting while depicting modern-day people.

179. The mood is lighthearted but not silly; the paintings are skillfully painted in a realistic style.

180. The portrait conveys confidence, royalty, power, and pride. The painting seems to be serious, but it is humorous because of the juxtaposition of Renaissance objects and clothing with the modern-day figure of Ice-T. Student descriptions will vary.

Web Resources by Topic

Prehistoric

Prehistoric cave paintings at Lascaux, France, pp. 1–5

 www.lascaux.culture.fr/#/en/00.xml

Venus of Willendorf, stone statuette, pp. 6–7

 www.hermitagemuseum.org/html_En/03/hm3_2_1.html

Egyptian

Portrait Panel of Hesy-ra, Saqqara, wood relief carving, p. 8

Great Pyramids, Giza, p. 9

Egyptian hieroglyphics, pp. 10–13

 www.metmuseum.org/Works_of_Art/egyptian_art

 www.greatbuildings.com

Assyrian

Ashurnasirpal II Killing Lions, Palace of Ashurnasirpal II, Nimrud, Iraq, stone panel, pp. 14–15

Audience Hall of Darius and Xeres, Persepolis, Iran, pp. 16–18

 www.metmuseum.org/works_of_art/department.asp?dep=3&vW=1

Aegean

Carved marble figure from Amorgos, Cyclades, pp. 19–20

Octopus Vase, Palaikastro, Crete, pp. 21–22

 www.metmuseum.org/toah/hd/ecyc/hd_ecyc.htm

Greek

Psiax, *Herakles Strangling the Nemean Lion*, Attic black-figured amphora, pp. 23–25

Female figure, limestone sculpture (kore), Archaic style, p. 26

Daily Warm-Ups: Art History

Greek orders of architecture, p. 27

The Parthenon, Athens, pp. 28–29

Greek Theater, Epidaurus, p. 30

Discobolus, *Discus Thrower*, bronze sculpture, Classical style, p. 31

Three Goddesses, sculpture, Parthenon, p. 32

Nike of Samothrace, marble sculpture, Hellenistic style, p. 33

Alexander the Great with Amun Horns, silver coin, pp. 34–35

 www.metmuseum.org/Works_of_Art/installation_gr.asp

 www.hermitagemuseum.org/html_En/03/hm3_1.html

 www.greatbuildings.com

Etruscan

She-Wolf, bronze sculpture, pp. 36–37

 www.bluffton.edu/~sullivanm/italy/rome/capitolinemuseumone/shewolf.html

Roman

Roman architecture: arch, barrel vault, groin vault, p. 38

Pont du Gard Aqueduct at Nimes, p. 39

The Colosseum, Rome, pp. 40–41

The Pantheon, Rome, pp. 42–43

 www.greatbuildings.com

Triumph of Titus, relief sculpture, Arch of Titus, Rome, pp. 44–45

 www.bluffton.edu/~sullivanm/titus/titus.html

Equestrian Statue of Marcus Aurelius, bronze sculpture, Piazza del Campidoglio, Rome, p. 46

> www.italian-architecture.info/ROME/RO-014.htm

Christian/Byzantine

Jacob Wrestling the Angel, page from the *Vienna Genesis*, pp. 47–50

> www.kean.edu/~jtuerk/images/4_Byzantine/08_MidByzIllMS/02.jpg

Empress Theodora and Her Attendants, mosaic, San Vitale Church, Ravenna, pp. 51–53

> www.greatbuildings.com/buildings/San_Vitale.html

Virgin and Child Enthroned Between Saints and Angels, painting, Monastery of St. Catherine, Sinai, pp. 54–57

> http://campus.belmont.edu/honors/SinaiIcons/SinaiIcons.html
>
> www.touregypt.net/Catherines.htm

Medieval

Animal head from the Oseburg ship, carved wood, Norway, pp. 58–61

 www.metmuseum.org/Works_of_Art/medieval_art

 www.bbc.co.uk/schools/primaryhistory/vikings/vikings_at_sea

Chi-Rho page from the *Book of Kells*, pp. 62–63

 www.hmml.org

Medieval animal art style, p. 64

 www.metmuseum.org/Works_of_Art/medieval_art

Gothic

Jamb statues of Chartres Cathedral, France, pp. 65–67

 www.greatbuildings.com/buildings/Chartres_Cathedral.html

Lorenzo Ghiberti, *Sacrifice of Isaac*, bronze door, Florence, pp. 68–69

 www.wga.hu

Notre Dame de la Belle Verriere, stained-glass window, Chartres Cathedral, pp. 70–72

 www.notredamedeparis.fr/-English-

Arena Chapel, interior view, Padua, Italy, p. 73

Giotto, *The Lamentation*, painting, p. 74

 www.wga.hu/frames-e.html?/html/g/giotto/padova

Jean Pucelle, *The Betrayal of Christ* and *The Annunciation*, pages from *The Hours of Jeanne d'Evreux*, p. 75

 www.metmuseum.org/explore/Jde/jdesplash.htm

 http://employees.oneonta.edu/farberas/arth/images/arth_214images/manuscripts/jeanne_d_evreux/annunciation.jpg

The Limbourg Brothers, October Calendar from *Les Très Riches Heures du Duc de Berry*, pp. 76–78

 www.wga.hu/frames-e.html?/html/l/limbourg/

Daily Warm-Ups: Art History

Italian Renaissance

Fra Angelico, *The Deposition*, painting, pp. 79–80

www.wga.hu/frames-e.html?/html/a/angelico/08/3trinita.html

Pietro Perugino, *The Delivery of the Keys*, painting, pp. 81–83

www.christusrex.org/www1/sistine/K.html

Leonardo da Vinci, *Mona Lisa*, painting, pp. 84–86

www.louvre.fr/llv/dossiers/visu_oal.jsp?CONTENT%3C%3Ecnt_id=10134198673229908&
CURRENT_LLV_OAL%3C%3Ecnt_id=10134198673229908&FOLDER%3C%3Efolder_
id=9852723696500764&bmLocale=en

Michelangelo, *Pietà*, marble sculpture, pp. 87–89

www.italian-renaissance-art.com/Michelangelo-sculptures.html

Raphael, *The School of Athens*, painting, pp. 90–92

www.wga.hu/frames-e.html?/html/r/raphael/4stanze/1segnatu/1/

El Greco, *The Burial of Count Orgaz,* painting, pp. 93–94

> www.el-greco-foundation.org/The-Burial-of-Count-Orgaz.html

Martin Schongauer, *The Temptation of St. Anthony,* engraving, p. 95

> www.britishmuseum.org/explore/highlights/highlight_objects/pd/m/martin_schongauer,_the_temptat.aspx

Albrecht Dürer, *The Four Horsemen* from *The Apocalypse,* woodcut print, p. 96

> www.metmuseum.org/toah/hd/durr/ho_19.73.209.htm

Jan Vermeer, *The Love Letter,* painting, pp. 97–100

> www.rijksmuseum.nl/aria/aria_assets/SK-A-1595?lang=en

Baroque/Rococo

Palace of Versailles, France, p. 101

> http://en.chateauversailles.fr/index.php?option=com_cdvhomepage

Daily Warm-Ups: Art History

Louis-François Roubiliac, marble sculpture of George Frideric Handel, pp. 102–103

www.vam.ac.uk/collections/sculpture/stories/Roubiliac's_Handel/index.html

Neoclassicism/Romanticism

John Singleton Copley, *Watson and the Shark*, painting, p. 104

www.nga.gov/cgi-bin/pinfo?Object=46188+0+none

Honoré Daumier, *The Third-Class Carriage*, painting, pp. 105–108

www.metmuseum.org/toah/hd/rlsm/ho_29.100.129.htm

Frédéric-Auguste Bartholdi, *Statue of Liberty*, copper sculpture, pp. 109–110

www.nps.gov/stli/index.htm

Realism/Impressionism

Mary Cassatt, *The Child's Bath*, painting, pp. 111–112

> www.marycassatt.org

Henry O. Tanner, *The Banjo Lesson*, painting, pp. 113–116

> www.pbs.org/wnet/aaworld/arts/tanner.html

Claude Monet, *Water Lilies*, paintings, pp. 117–118

> http://painting.about.com/od/arthistorytrivia/ig/Gallery-of-Famous-Paintings/Monet-Water-Lilies.htm

Auguste Rodin, *The Thinker,* bronze sculpture, pp. 119–121

> www.musee-rodin.fr/welcome.htm

Edgar Degas, *Little Dancer of Fourteen Years*, sculpture, mixed media, p. 122

> www.tate.org.uk/servlet/ViewWork?workid=3705

Post-Impressionism

Paul Cézanne, landscape paintings, p. 123

www.ibiblio.org/wm/paint/auth/cezanne/land

Georges Seurat, *A Sunday on La Grande Jatte—1884*, painting, pp. 124–125

www.artic.edu/artaccess/AA_Impressionist/pages/IMP_7.shtml

Henri de Toulouse-Lautrec, posters, p. 126

www.nga.gov/exhibitions/2005/toulouse/cafes.shtm

Vincent Van Gogh, paintings, pp. 127–128

www3.vangoghmuseum.nl/vgm/index.jsp?page=98&lang=en

Katsushika Hokusai, *The Great Wave at Kanagawa*, color woodcut, pp. 129–131

www.metmuseum.org/works_of_art/collection_database/objectview.aspx?oid=60013238

20th Century

Henri Matisse, *Red Studio*, painting, p. 132

Henri Matisse, cutout series, collage, p. 133

 www.musee-matisse-nice.org

Marc Chagall, *I and the Village*, painting, p. 134

 www.moma.org/collection/object.php?object_id=78984

Pablo Picasso, *Guernica*, painting, pp. 135–136

 www.museoreinasofia.es/index_en.html

Piet Mondrian, *Composition with Yellow, Blue, and Red*, painting, pp. 137

 https://www.tate.org.uk/servlet/ViewWork?cgroupid=999999961&workid=9603

Salvador Dalí, *The Persistence of Memory*, painting, pp. 138–139

 www.moma.org/collection/object.php?object_id=79018

Frida Kahlo, self-portrait series, paintings, pp. 140–141

 www.sfmoma.org/exhibitions/310#

Joan Miró, paintings, pp. 142–145

 http://fundaciomiro-bcn.org/joanmiro.php?idioma=2

Georgia O'Keeffe, paintings, pp. 146–148

 www.okeeffemuseum.org

Jacob Lawrence, *The Great Migration* series, paintings, pp. 149–152

 http://whitney.org/jacoblawrence/resources/webqst_migr_3.html

Romare Bearden, mixed media, p. 153

 www.beardenfoundation.org

Faith Ringgold, story quilts, mixed media, pp. 154–156

 www.faithringgold.com

Andy Warhol, *Marilyn Diptych*, silkscreen painting, pp. 157–159

>www.tate.org.uk/servlet/ViewWork?cgroupid=-1&workid=15976&searchid=false&roomid=false&tabview=text&texttype=9

Keith Haring, drawings/paintings, pp. 160–163

>www.haringkids.com/index.html (preview before using in class)

James Van Der Zee, photography, p. 164

>www.dia.org/asp/search/ExecuteSearch.asp?artist=James+VanDerZee&AID=11823

Alfred Stieglitz, *The Steerage*, photograph, pp. 165–166

>www.metmuseum.org/toah/hd/stgp/ho_33.43.419.htm

Robert Frank, photography, p. 167

>www.nga.gov/exhibitions/2009/frank/index.shtm

Dorothea Lange, *The Migrant Mother*, photograph, p. 168

>www.loc.gov/rr/print/list/128_migm.html

Daily Warm-Ups: Art History

Maya Lin, *Vietnam Veterans Memorial*, sculpture/monument, pp. 169–170

www.pbs.org/art21/artists/lin/card1.html

Frank Gehry, architecture, p. 171

www.greatbuildings.com/architects/Frank_Gehry.html

Frank Lloyd Wright, architecture, p. 172

www.greatbuildings.com/architects/Frank_Lloyd_Wright.html

Contemporary

Graffiti art, pp. 173–175

www.graffiti.org

SunTek Chung, photography, pp. 176–177

www.suntekchung.com

Kehinde Wiley, portrait paintings, pp. 178–180

www.kehindewiley.com

www.npg.si.edu/exhibit/recognize/paintings.html

Additional Online Resources

The Metropolitan Museum of Art

www.metmuseum.org

The Museum of Contemporary Art, Los Angeles

www.moca.org

The Museum of Modern Art

www.moma.org

The Louvre

www.louvre.fr

Daily Warm-Ups: Art History

The Ansel Adams Gallery

 www.anseladams.com

New Museum

 www.newmuseum.org

Smithsonian Institution—Museums

 www.si.edu/Museums

Smithsonian National Portrait Gallery

 www.npg.si.edu

National Gallery of Art, Washington

 www.nga.gov

Hirshhorn Museum and Sculpture Garden

 http://hirshhorn.si.edu